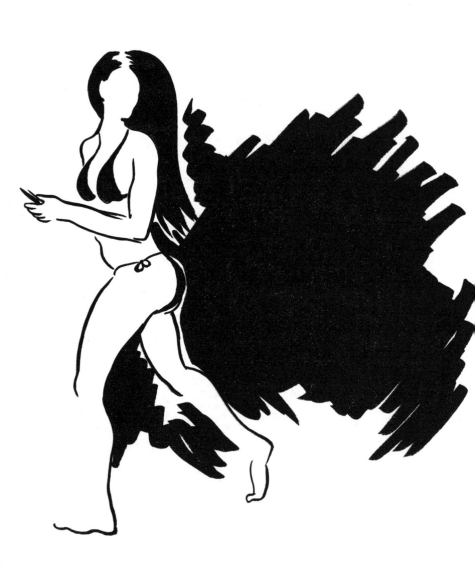

My

BEAUTIFUL DESPAIR

THE PHILOSOPHY OF

Kim Kierkegaardashian

Illustrations by Dash Shaw

TOUCHSTONE

New York London Toronto Sydney New Delhi

Touchstone
An Imprint of Simon & Schuster, Inc.
1230 Avenue of the Americas
New York, NY 10020

First Touchstone hardcover edition July 2018

TOUCHSTONE and colophon are registered trademarks of Simon & Schuster, Inc.

For information about special discounts for bulk purchases, please contact Simon & Schuster Special Sales at 1-866-506-1949 or business@simonandschuster.com.

The Simon & Schuster Speakers Bureau can bring authors to your live event. For more information or to book an event, contact the Simon & Schuster Speakers Bureau at 1-866-248-3049 or visit our website at www.simonspeakers.com.

Interior design by Jill Putorti
Illustrations by Dash Shaw

Manufactured in the United States of America

10 9 8 7 6 5 4 3 2 1

Library of Congress Cataloging-in-Publication data is available.

ISBN 978-1-9821-0098-8
ISBN 978-1-9821-0100-8 [ebook]

For all those living in times of despair
who still manage to look their best

INTRODUCTION
WHO IS KIM KIERKEGAARDASHIAN?

I first met Kim Kierkegaardashian in 2018, in Los Angeles. Although my bread and butter is the teaching of philosophy, I am a notorious *bon vivant*, and I frequent fashion shows and *soirées* whenever possible, particularly when I am in America. I find there is nowhere better to understand philosophy's penetrating critique than among the wealthy. I was at a gathering at the home of an actor who had once been a student of mine, when I noticed a person who was standing just apart from everyone else and yet was the object of considerable attention: a figure, notable even among that attractive crowd for radiating an intense charisma, dressed with incredible flair, and whose face projected an air of deep intelligence.

I asked my host who this remarkable person was. I was informed that it was Kim Kierkegaardashian.

Now, most of you may know Kim Kierkegaardashian as the creator of the popular eponymous Twitter account, which has been described as an amalgamation of the world of the American reality star Kim Kardashian West with the philosophy of Søren Kierkegaard, the Danish

existentialist philosopher who died in 1855. The musings therein seem to combine some words uttered or tweeted by Ms. West, combined with bits and fragments from the numerous tomes of *Herr* Kierkegaard.

As parody, the work is *par excellence*, for it pokes fun at the reality star while also taking the wind out of the sometimes ponderous Mr. Kierkegaard. But, as I and many of my colleagues aver, Kim Kierkegaardashian's words do not exist as mere mockery. Indeed, some of the aphorisms seem to show us a heretofore unnoticed depth to the life of the reality star, and add a surprising *frisson* of contemporaneity to the work of the Danish philosopher. And indeed, as the best writing may do, these pithy sayings transcend their subject matter, to be read as statements on existence more broadly.

I, too, was an admirer of the work. But up until that evening in Los Angeles, I had assumed that Kim Kierkegaardashian existed merely as a construct of language. Never had I suspected that this figure from the Internet was indeed an *actual person*.

But here, standing before me, was that same person. To be clear, this was not the person *behind* the Internet persona. Rather, standing here was the true Kim Kierkegaardashian, the living embodiment of the two disparate cultural figures, united into one flesh.

Emboldened by a flute or two of *champagne* (which is my preferred drink, even in the States) I dared to approach. I introduced myself as an admirer. Those remarkable dark eyes lit up, charming pleasantries were exchanged, and from that mouth came witty and hilar-

ious lines—insights into the world of fashion, observations about the culture of celebrity, apparently mundane tips about makeup, followed by profound and insightful quips that peeled back the truth of our strange times, and seemed to expose the meaning of life itself. I made a comment on the lovely scent of perfume I detected. "Ah, my new fragrance," came the reply. "It smells of modern life's nauseating air."

Now each time Kierkegaardashian spoke, it was only very brief—let us say, roughly 140 characters, and then the eyes would briefly fall, and one could detect a sigh escape from those otherworldly lips.

I had the sudden fear of wearying the great mind with too much idle chatter, and excused myself to the bar. But I saw that no sooner did I step away than others approached—fans and admirers—to bask in the glow. The beautiful, thoughtful face would light up, out from that well-formed mouth would pour forth wisdom and *bon mots*, the surrounding crowd would respond with appreciative laughter, they would raise their glasses here and there in appreciation. I heard someone in the crowd mention that Kierkegaardashian was expected soon to pay a visit to a fellow celebrity in the White House. I was somehow not surprised. Was not the glamorous philosopher perfectly suited to show the man in the Oval Office the despair in which he unconsciously dwells, and to give him tips on toning down his orange glow besides?

I asked myself: Who was this remarkable person who was here, and

yet not here? This person who was the life of the party, and yet who seemed so completely set apart from the crowd? Who seemed at times so cheerful, and then so very sad?

As I looked into Kierkegaardashian's eyes, I came to the following conclusion. That here was a person for whom this party, this life of celebrity and beauty and fashion and politics, was all a distraction from more profound and serious concerns. Even though she stood at the center of such glamour, even though she was surrounded by people whose lives were steeped in money and glitter, the accoutrements of such lives—the private planes, the smartphones, the *couture* gowns, the glossy magazines—were exactly the things that interested Kim Kierkegaardashian *least*.

I had by now downed several more flutes of *champagne*, in direct contradiction to my doctor's orders. I grew more attracted to that solemn yet cheerful figure. I walked across the room once more . . .

I woke up the next morning with a headache and a stomach unsettled from the previous evening's excess. I was alone. I wondered if that wondrous meeting with my intellectual and comedic hero had been a dream. I turned over in my bed and saw on my nightstand, among my sundries, a stack of manuscript pages.

What was this? Where had it come from? I fumbled for my reading glasses and picked it up.

Scribbled on the cover page was a brief note thanking me for my attention to the text. It was signed with Kierkegaardashian's name. So it had not been a dream?

I read through the pages with great interest. The manuscript was, it would seem, a distillation and articulation of Kierkegaardashian's greatest wisdom. It was remarkable. I knew immediately that it demanded publication. As I read, I very seriously analyzed the writing. While many if not most of the aphorisms had their sources in the words presented in some medium by Ms. West and, correspondingly, from the works of *Herr* Kierkegaard, I found that there were other passages for which no source material could be detected. Or was that an illusion created by the combination—had the marriage of opposites erupted in the birth of something completely original?

As I read and reread the work, I searched for clues, for insights into the nature of Kierkegaardashian the human being. I began to revise my previous evening's estimation. For while Kierkegaardashian is, in one sense, weary of the world, the world in all its absurdity and excess and falseness; in another sense, this world of surfaces is precisely what most fascinates that remarkable mind. The work seeks to puncture that world—to show the despair hidden just behind it—but also seems to embrace it. And there is a distinct sense, as one reads, of a gentle humanity. Sometimes cutting, but often compassionate. We are all of us, after all, a union of opposites, the temporal and the eternal. Kierkegaardashian holds a mirror to us and sends us the following message:

This is how we are. Love yourselves and each other. Perhaps become better.

I set down the manuscript and became aware, about my person, most pleasantly, of a trace of the smell of modern life's nauseating air.

<div align="right">

—R. Shamspeare,

Professor of Philosophy emeritus,

University of East Cambria

</div>

My
BEAUTIFUL
DESPAIR

"I have majorly fallen off my workout eating plan! AND it's summer. But to despair over sin is to sink deeper into it."

"A white blouse is classic. It says: my pain and my suffering are nameless; there is no one who understands me."

"Obsessed with protecting your skin, lips, hair & face from the sun? Close the cover of the coffin tight—really tight— and be at peace."

"Lazy day poolside! Best French toast ever. No other loss can occur so quietly as the loss of one's self."

"Matte makeup reminds a person of what he truly is—nothing."

"I see all of your tweets and Instagrams and am certain that you have failed to understand the reality of death."

"I like my men like I like my coffee:
a momentary comfort in the
midst of all my suffering."

"Dressing for fall can be tough. Even a go-to sweater can't insulate you from despair."

"I feel dull and without joy;
my soul is so empty & void.
Black liner, messy hair kinda day."

"Glamour, menswear, top hat . . .
I stick my finger into existence,
and it smells of nothing."

"Cleaned out my closet.
But I am still a burden to myself."

"My look is never complete
without indescribable suffering."

"Rise & grind! Busy day!!
Gym then packing 4 Paris again!
This is the despair of finitude,
when the self is lost to the temporal,
the trivial."

"Weary of people, weary of myself, so weary that I need an eternity to rest. That's why I always carry a pillow when I'm traveling."

"A good skin-care routine can have so many benefits, but it does not captivate the mind as death does."

"I'm up so early. Do I work out or try to go back to sleep? My honest opinion is this—I will regret both."

"God grant me peace from my foolish earthly desires, my wild longings, the anxious cravings of my heart. I'm craving fro-yo so badly."

"Kanye and I are in Venice, walking around and taking in the sights. I wonder if he is capable of knowing anything about the truth."

"My skin looks fantastic,
but my suffering borders on madness."

"I have done so many makeup looks and styles, but am unable to transform myself."

"Everyone looked so great on the red carpet, like captive beasts walking round in their cages, or measuring the lengths of their chains."

"Awww, Kanye won 3 Grammys!! That makes a total of 21!!! Sooo proud!! But it avails nothing, being only a higher and more glittering illusion."

"I love your Tumblr's infinite scroll-down feature & the unfathomable, insatiable emptiness behind it."

"Today's look: a terrible, insatiable existential hunger, plus my new favorite boots."

"Always be open to new hair looks! They divert you from the passing of life and postpone the moment when you have to face your conscience."

"I cashed my $80 mil check & transferred $53 mil to our joint account. Yet I fear I do not possess the world, rather the world possesses me."

"I love having two phones with different services, so I always have a working phone and never a moment for reflection."

"My dates tonight:
mortification and solitude."

"I always regret when I try long nails. They remind me too poignantly of the sharp scythe of the reaper."

My top 5 Instagram tips:

I.
Really feel your nothingness.

2.
There is the smile that is the cousin of pain,
the insincere smile, the smile of blessedness, and duck face.

3.
Convey how your suffering is palpably unique.

4.
Earthly life is brief and frail, so try to vary your outfits.

5.
However much the world changes, weeping has been
and always will be completely natural to humankind.

"What is the operation by which a self relates itself to its own self, transparently? Selfie."

"Want a red-carpet look for New Year's?
Clothe yourself in pain."

"Contouring is an amazing way to shape your nose and define your cheeks, but only terror to the point of despair develops a man to his utmost."

"Here's a quick anti-aging trick: die."

"To boldly venture the truth is what gives human life and the human situation pith & meaning. Take a chance on harem pants."

"I wanted to create a fashion line for little girls, lest they should rest too easily in the false security of youth."

"Hegelian philosophy posits the thesis that the outer is the inner & the inner is the outer, but I think it's elegant to twist it into a bun."

"A nude lip is subtle. It asks, Who is this pallid figure, who tried to carry a world but overstrained himself, and broke his soul?"

"My ship plowed through the storm.
Looking into the waves, I grew dizzy,
for I glimpsed the chasm between
myself & the infinite. Yacht life."

"How cunningly I am able to hide my depression. I literally just put a lot of shimmer on my face and just walk around."

"My red-carpet cleavage secret: beat your breast and cry, 'God, be merciful to me, a sinner.'"

"Last night's look: Balmain dress, Kanye West heels, a sickness of the spirit, and an anxiety I cannot explain."

"You can achieve rosy, healthy, blushed-pink cheeks simply by stepping out into the cold. This is eternity's comfort for the sufferer."

"Each individual fights for himself, with himself, within himself, in order to free himself before God. I'm gonna be sooo sore tomorrow."

"Filling in the eyebrows with a pencil or powder helps eliminate the imperfection that pertains to everything human."

"I have been going to bed a little bit earlier each night, to get a taste of death."

"A military jacket gives an outfit that extra edge without making it too hard or rough. It says: my fight is not with man, but with God."

"The aviator jacket is trending. It says: we have flown aloft, as high as we can, and now like Satan we are falling."

"Again I am burdened by a heaviness of the soul. Not gonna call it baby weight bc that's an excuse."

"Summer's easiest hair trend is beach waves.
It says: the seas of life are rough
and I am drowning."

"After my death, no one will find among my papers a single explanation as to what really filled my life: sour cream and onion potato chips."

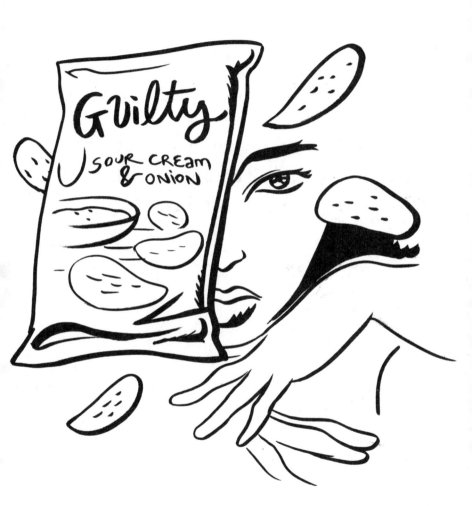

"You laugh at my nakedness, yet you yourselves wear not a shred of intellectual or moral clothing."

"A fire has been set to the tinder which is in your soul. It's bright and classic and adds a pop of color to your fall look."

"Every human interpretation is only a misconception, and all my troubles are like a sophism to which I say, OMGGGGG O.M.G. I can't even!!!"

"Eyebrows on fleek. This is as close as I can come to approaching the absolute."

"I know that pleasure and light-mindedness draw us away from ourselves in order to deceive us, yet I feel so very comfortable eating churros."

"My boo is back in town. I am referring to my inescapable melancholy."

"It is powerful like a god's idea, turbulent like a world's life, harrowing in its earnestness. Diet peach Snapple is my everything."

"I love taking fashion trends & applying them to interior design, because in the end, we each fight our battle in the solitude of our own room."

"I'm not trying to shade anyone,
but it is my destiny to discourse on truth
in such a way that all authority is
simultaneously demolished."

"Aww!! Kim & Kanye is trending.
The world—no matter how
imperfect—becomes rich & beautiful;
it consists solely of opportunities to love."

"You exist. You are a human being.
The sun shines for you, and your eyebrows
are thick, natural & amazing."

"I took off those long press-on nails. OMG, I can text & tweet again. And therefore someday my writings will be studied and studied."

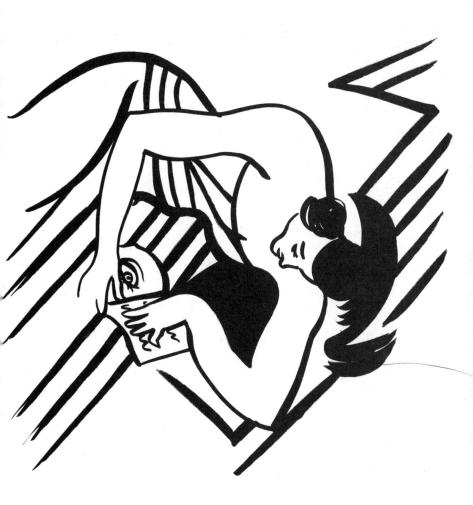

ACKNOWLEDGMENTS

Dash Shaw would like to thank Jane, Castle, Raj, Nicole, Gracie, and Lauren.

Kim Kierkegaardashian would like to thank Versace, Balenciaga, Gucci, Kanye, and Hegel.

ABOUT THE AUTHOR

Kim Kierkegaardashian is the living unity of reality star Kim Kardashian West and nineteenth-century Danish philosopher Søren Kierkegaard.

ABOUT THE ILLUSTRATOR

Dash Shaw is the cartoonist of *Doctors, Cosplayers, New School,* and other graphic novels. He wrote and directed the 2016 independent animated feature *My Entire High School Sinking into the Sea*.